CONDENSED ALPHABETS
100 COMPLETE FONTS

SELECTED AND ARRANGED BY
DAN X. SOLO
FROM THE
SOLOTYPE TYPOGRAPHERS CATALOG

DOVER PUBLICATIONS, INC. · NEW YORK

Copyright © 1986 by Dover Publications, Inc.
All rights reserved under Pan American and International Copyright Conventions.

Published in Canada by General Publishing Company, Ltd., 30 Lesmill Road, Don Mills, Toronto, Ontario.
Published in the United Kingdom by Constable and Company, Ltd., 10 Orange Street, London WC2H 7EG.

Condensed Alphabets: 100 Complete Fonts is a new work, first published by Dover Publications, Inc., in 1986.

DOVER *Pictorial Archive* SERIES

Condensed Alphabets: 100 Complete Fonts is a title in the Dover Pictorial Archive Series. Up to six words may be composed from the letters in these alphabets and used in any single publication without payment to or permission from the publisher. For any more extensive use, write directly to Solotype Typographers, 298 Crestmont Drive, Oakland, California 94619, who have the facilities to typeset extensively in varying sizes and according to specifications. The republication of this book as a whole is prohibited.

Manufactured in the United States of America
Dover Publications, Inc., 31 East 2nd Street, Mineola, N.Y. 11501

Library of Congress Cataloging-in-Publication Data

Condensed alphabets.

(Dover pictorial archive series)
1. Printing—Specimens. 2. Type and type-founding. 3. Alphabets. I. Solo, Dan X. II. Solotype Typographers.
Z250.C745 1986 686.2′24 86-6380
ISBN 0-486-25194-2 (pbk.)

Alternate Gothic No.1

ABCDEFGHIJ
KLMNOPQRSTUV
WXYZ
abcdefghijklmn
opqrstuvwxyz
1234567890
&;!?-'$

AMBELYN CONDENSED

ABCDEFGHIJKL
MNOPQRSTU
VWXYZ
1234567890
(&;-'!?$)

American Narrow

ABCDEFGHIJKLMNOPQRS
TUVWXYZ

abcdefghijklmnopqrstuvwxyz
1234567890
(&;'-!?$¢)

American Text Compressed

ABCDEFGHIJKLM
NOPQRSTUVWXYZ

abcdefghijklmn
opqrstuvwxyz

1234567890 [&;"-!?$]

Aurora Condensed

AABCDEFGHIJKKLMM
NNOPQRSTUUVW
WXXYYZ

abcdefghijkklmnopq
rstuvvwwxxyyz

1234456789O (&,:!?'-$)

ABCDEFGHIJKLM
NOPQRSTUVWXYZ

abcdefghijklmn
opqrstuvwxyz

1234567890 (&,‰!?$)

Bellery Elongated

ABCDEFGHIJKLMN
OPQRSTUVWXYZ
abcdefghijklmnop
qrstuvwxyz
1234567890 &;:!?

Bernhard Bold Extra Condensed

ABCDEFGHIJKLM
NOPQRSTUVWXYZ

abcdefghijklm
nopqrstuvwxyz

1234567890(&;-'!?$)

Binder Style Heavy

ABCDEFGHIJ
KLMNOPQRS
TUVWXYZ
abcdefghijkl
mnopqrstluv
wxyz123456
7890$&!?

BINNER GOTHIC

ABCDEFGHIJKL
MNOPQRSTUVW
XYZ
abcdefghijklmn
opqrstuvwxyz
(&;!?$)
1234567890

Block Condensed

ABCDEFGHIJK
LMNOPQRST
UVWXYZ
abcdefghiijklm
nopqrstuvwxyz

(&,.!?"'$)

1234567890

CAPTAIN NEMO

ABCDEFG
HIJKLMNOPQ
RSTUVWX
YZ?!£

1234567890

Casablanca Light Condensed

ABCDEFGHIJKLM
NOPQRSTUVWXYZ
abcdefghijklm
nopqrstuvwxyz

(&.,:;!?"$)
1234567890

Caslon Bold Extra Condensed

ABCDEFGHIJKLM
NOPQRSTUV
WXYZ

abcdefghijklmnopq
rstuvwxyz

1234567890 (&,:!?'-$)

DOANA KORAN
NEW YORK

Century Bold Condensed

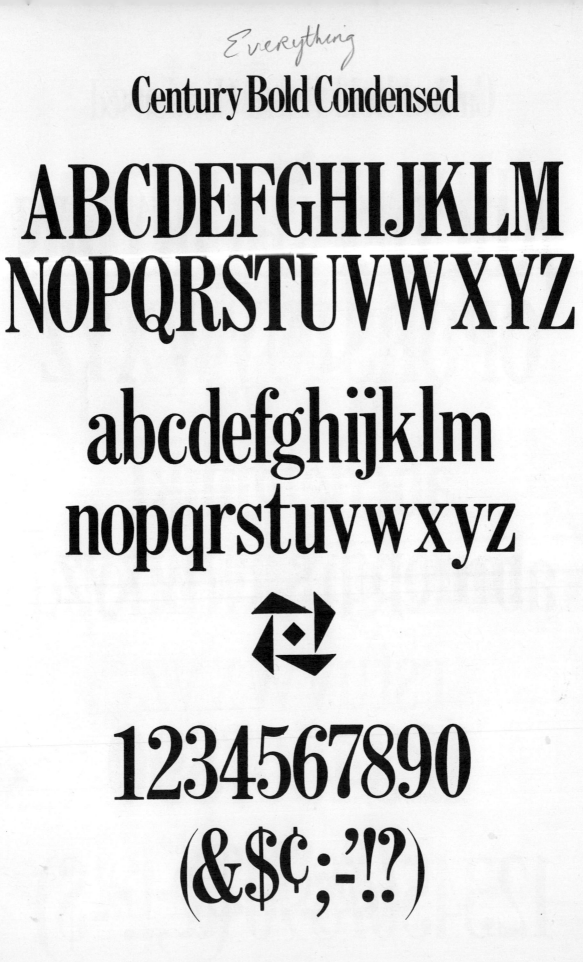

ABCDEFGHIJKLM
NOPQRSTUVWXYZ

abcdefghijklm
nopqrstuvwxyz

1234567890

(&$¢;-'!?)

Cheltenham Bold Ex.Cond.

ABCDEFGHIJKLMN
OPQRSTUVWXYZ

abcdefghijkl
mnopqrstuvwxyz

1234567890
(&;!?"-$)

Cooper Black Extra Condensed

ABCDEFGHIJKL
MNOPQRSTU
VWXYZ

abcdefghijklmnop
qrstuvwxyz

1234567890 [&;!?$]

Corvinus Skyline

ABCDEFGHIJKLM
NOPQRSTUVWXYZ
&
abcdefghijklmnop
qrstuvwxyz

$

1234567890 (;!?)

DAWSON CONDENSED

ABCDEFGHIJ
KLM
NOPQRSTUV
WXYZ
1234567890
&,'!?$

Denver

ABCDEFGHIJKLMNOP
QRSTU VWXYZ

abcdefghijklmnopqr
stuvwxyz

1234567890;'-!

Donna

ABCDEFGHI
JKLMNOPQR
STUVWXYZ
abcdefghijklmn
opqrstuvwxyz

1234567890!?;$

DOUBLETIME

ABCDEFGHIJKLMNOPQR
STUVWXYZ

abcdefghijklmnopqrstuvwxyz

1234567890 (&;'-!?$)

Egizio Extra Condensed

ABCDEFGHIJKLM
NOPQRSTUVWXYZ

abcdefghijklmn
opqrstuvwxyz

1234567890 (&;'!?$)

EMPIRE

ABCDEFGHIJ

KLMNOPQRSTU

VWXYZ & $! ?

⌣

1234567890

Enge Wotan

ABCDEFGHIJKLM
NOPQRSTUVWXYZ
abcdefghijklmn
opqrstuvwxyz
&,.:!?
$1234567890

Erbar Medium Condensed

ABCDEFGHIJKLM
NOPQRSTUVWXYZ

abcdefghijklmn
opqrstuvwxyz

1234567890&;!?$

Facade Condensed

ABCDEFGHIJKLMNOPQRS
TUVWXYZ

abcdefghijklmnopqrstu
vwxyz

1234567890$&;!?

Franklin Gothic Extra Condensed

ABCDEFGHIJKLM
NOPQRSTUV
WXYZ

abcdefghijklmno
pqrstuvwxyz
(&;-"!?$)
1234567890

Futura Medium Condensed

ABCDEFGHIJKLMN
OPQRSTUVWXYZ
abcdefghijklm
nopqrstuvwxyz

1234567890(&;!?$)

Gill Sans Bold Extra Condensed

ABCDEFGHIJKLMN
OPQRSTUVWXYZ

abcdefghijk
lmnopqrstuvwxyz

1234567890

(&.,:;-'"!?$¢£%)

Globe Gothic Condensed

ABCDEFGHIJKLMN
OPQRSTUVWXYZ

abcdefghijklmnop
qrstuvwxyz

1234567890&;!?

GRAND B

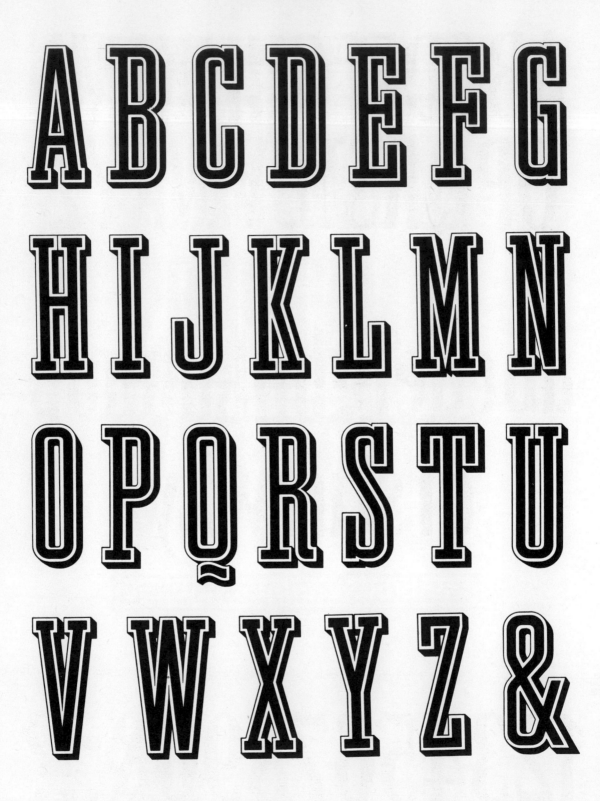

A B C D E F G
H I J K L M N
O P Q R S T U
V W X Y Z &

GRECIAN EXTRA CONDENSED

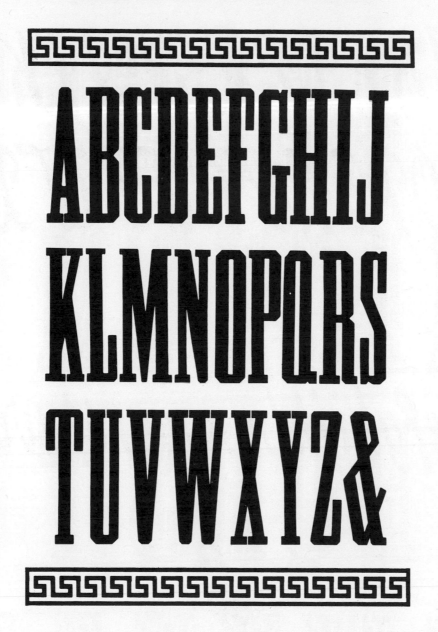

ABCDEFGHIJ
KLMNOPQRS
TUVWXYZ&

Grocers Condensed

ABCDEFGHIJKL

MNOPQRSTUVWXYZ

abcdefghijklmnopqrstuvwxyz

£

1234567890&;-'!?

HATHAWAY

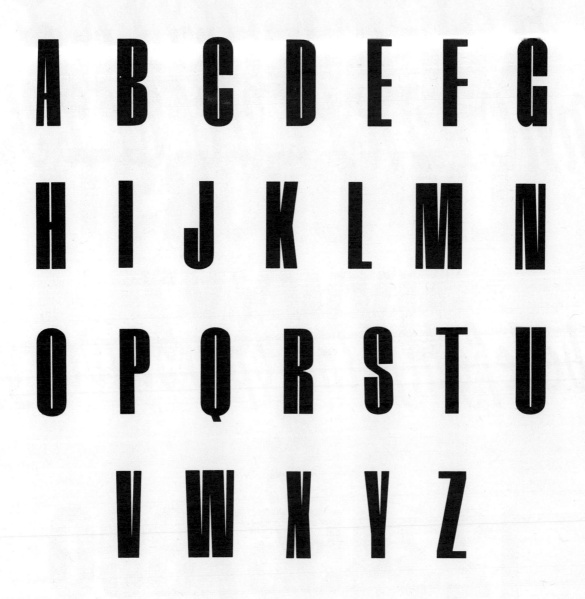

A B C D E F G
H I J K L M N
O P Q R S T U
V W X Y Z

HEADLINE GOTHIC

ABCDEFGHIJK
LMNOPQRST
UVWXYZ
&
1234567890
$

Helvetica Ultra Compressed

ABCDEFGHIJKLM
NOPQRSTUVWXYZ

abcdefghijklmn
opqrstuvwxyz

❋

1234567890 (&;:!?$)

Herald Gothic

ABCDEFGHIJKLM
NOPQRSTUVWXYZ
abcdefghijklmno
pqrstuvwxyz

[&;-!?$] 1234567890

Herald Square

ABCDEFGHIJKLM

NOPQRSTUVWXY

Z

abcdefgggghijjk

lmnoppqqrstuvw

xyz1234567890

!?

Herold Condensed

ABCDEFGHIJKLM
NOPQRSTUVWXYZ

abcdefghijklm
nopqrstuvwxyz

1234567890 (&$;!?)

Hohenzollern

ABCDEFGHIJKL
MNOPQRST
UVWXYZ
abcdefghijklmn
opqrstuvwxyz
1234567890

Honda Condensed

ABCDEFGHIJKLM
NOPQRSTUVWXYZ

abcdefghijklmno
pqrstuvwxyz

1234567890&;!?:$

Howland

ABCDEFGHIJK
LMNOPQRSTUV
WXYZ
abcdefghijklmno
pqrstuvwxyz

&;:-!?$

1234567890

HUXLEY VERTICAL

AABCDEFGHIJKKLMM

NNOPQRSTUVWWXYZ

1234567890

&.$!?

HUXLEY VERTICAL BOLD

AABCDEFGHIJKKLMM

NNOPQRSTUVWWXYYZ

1234567890

&;·$|!?

Ibsen Condensed

AaBCDEEFGHIiJJKKL

MMNNOPQRRrS

TUUVWXYZ

abcdeffghij jkklm

nopqrrsttuvwxyyz

(&;!?$¢)

1234567890

46

Inserat Grotesk

ABCDEFGHIJKLMNOPQR STUVWXYZ

abcdefghijklmnopqrstuvwxyz

1234567890 (&;:'!?$)

Jenson Bold Condensed B

ABCDEFGHIJKL
MNOPQR
STUVWXYZ
abcdefghijklmn
opqrstuvwxyz

1234567890&;:!?

Jodrell Bank

ABCDEFGHIJKLM
NOPQRSTUVWXYZ

abcdefghijklm
nopqrstuvwxyz

(&!?$:)

1234567890

JUANITA

ABCDEFG
HIJKLM
NOPQRST
UVWXYZ

Kid Ory B

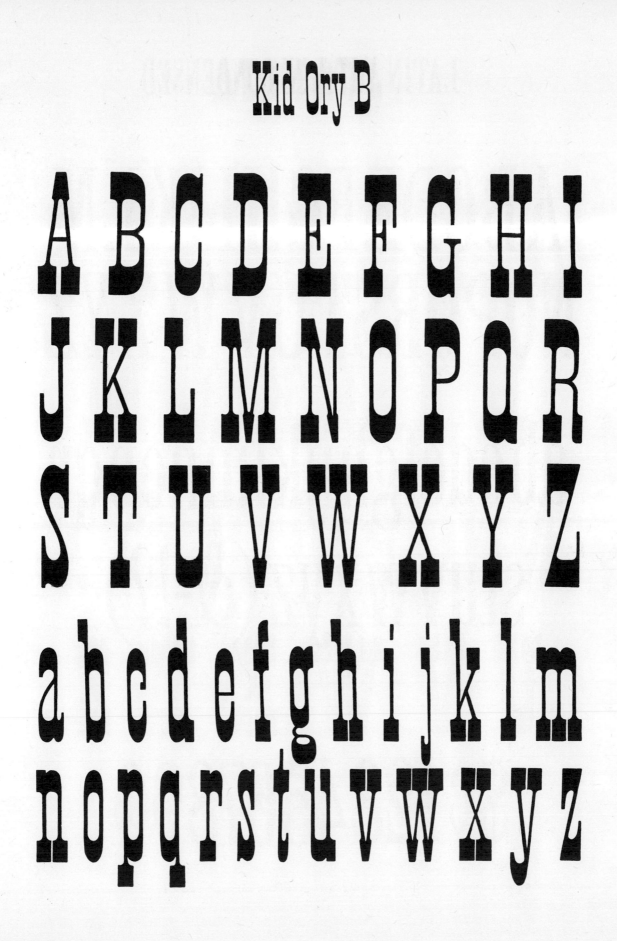

LATIN ANTIQUE CONDENSED

ABCDEFGHIJKLM
NOPQRSTUVWXYZ

abcdefghijklmnopqr
stuvwxyz (&;!?)

$¢1234567890

Latin Noir Etroit

ABCDEFGHIJKLMNO
PQRSTUVWXYZ&!?

abcdefghijklmnopqrs
tuvwxyz
1234567890

ABCDEFGHIJKLMN
OPQRSTUVWXYZ
&
abcdefghijklmnopq
rstuvwxyz

1234567890 («».,„:'-?!)

Lydian Bold Extra Condensed

ABCDEFGHIJKLM
NOPQRSTUVWXYZ
abcdefghijklmn
opqrstuvwxyz

1234567890 &;!?$¢

MAC B

A B C D E F G H
I J K L M N O P
Q R S T U V W X
Y Z 1 2 3 4 5 6
7 8 9 0 ?

MAHARAJA

A B C D E
F G H I J K
L M N O P
Q R S T U V
W X Y Z !

Mannequin

ABCDEFGHIJ
KLMNOPQR
STUVWXYZ
abcdefghijklmno
pqrstuvwxyz
1234567890

MARLA

A B C D E F G

H I J K L M N

O P Q R S T U

V W X Y Z

Mercator Condensed

ABCDEFGHIJK
LMNOPQRST
UVWXYZ
abcdefghijklmn
opqrstuvwxyz
&;!?
1234567890$£

MODERNA CONDENSED

ABCDEFGHIJK

LMNOPQRS

TUVWXYZ&

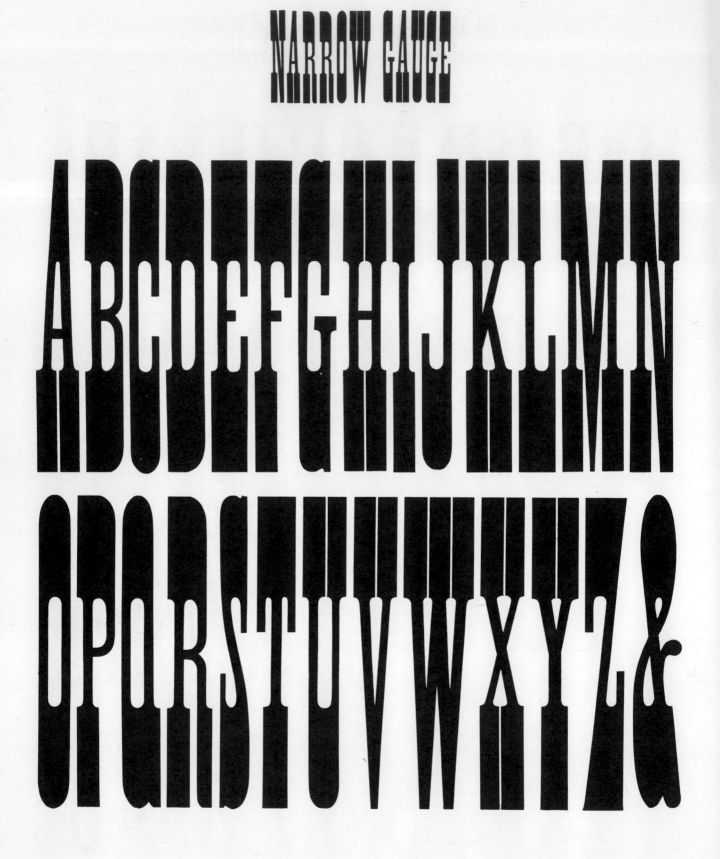

ABCDEFGHIJKLMN
OPQRSTUVWXYZ&

Newport Condensed

ABCDEFGHIJKLM
NO
PQRSTUVWXYZ

abcdefghijklmno
pqrstuvwxyz&?!

1234567890

ABCDEFGHIJKLM
NOPQRSTUVWXYZ

abcdefghijklm
nopqrstuvwxyz

1234567890

(&$¢/.,:;‘’!?-*)

Normande Condensed

ABCDEFGHIJK
LMNOPQRSTU
VWXYZ
abcdefghijklmn
opqrstuvwxyz
(&.,!?$)
1234567890

Onyx

ABCDEFGHIJKLMN
OPQRSTUVWXYZ

abcdefghijklm
nopqrstuvwxyz

$

1234567890 (&.!?"-)

Onyx Italic

ABCDEFGHIJKLMN
OPQRSTUVWXYZ

abcdefghijklm
nopqrstuvwxyz

1234567890 (&,.!?"-")

Party Time

ABCDEFGHIJKLMN
OPQQRSTUVWXYZ

abcdefghijjklmno
pqrrrsstuvwxyz

1234567890 [&!?˘˜$]

PHENIX

ABCDEFGHIJKLM
NOPQRSTUVWXYZ
abcdefghijklmn
opqrstuvwxyz

1234567890?!.:.,"$&

Placard

ABCDEFGHIJKLMN
OPQRSTUVW
XYZ
abcdefghijklmnopqr
stuvwxyz

1234567890

Planter's Punch

ABCDEFGHIJKLM
NOPQRSTUVWXYZ

abcdefghijklmnopqrstuvwxyz

1234567890 (&;!?$¢)

Radiant Bold Condensed

ABCDEFGHIJKLMNO
PQRSTUVWXYZ

abcdefghijklmnop
qrstuvwxyz

(&;.!?-'$)
1234567890

Radiant Bold Extra Condensed

ABCDEFGHIJKLMNO
PQRSTUVWXYZ

abcdefghijklmnop
qrstuvwxyz

1234567890 [&,.!?"-$]

RALEIGH GOTHIC

ABCDEFGHIJKL

MNOPQRSTUV

WXYZ&.,-'':.!?

$1234567890

Richmond Bold Compressed B

ABCDEFGHIJKLM NOPQRSTUVWXYZ

abcdefghijklmnop qrstuvwxyz

1234567890 (&;!?£)

ROBARD

ABCDEFGHIJK

!LMNOP?

QRSTUVWXYZ

$1234567890&

Rockwell Medium Condensed

ABCDEFGHIJKLM
NOPQRSTUVWXYZ
abcdefghijklmno
pqrstuvwxyz
(&.,-:;!?"'$)
1234567890

Rubens

ABCDEFGHIJKLMNO
PQRSTUVWXYZ

abcdefghijklmnop
qrstuvwxyz

1234567890 &:-?!

SCULPTURA

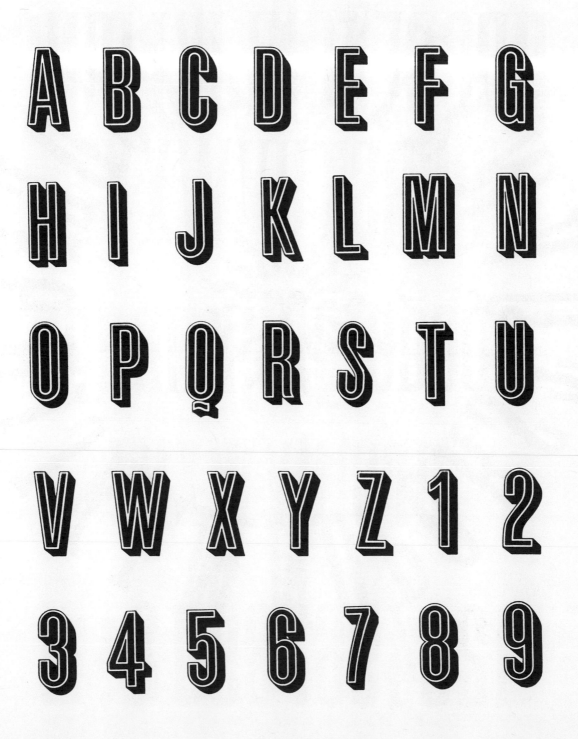

SHIMMER B

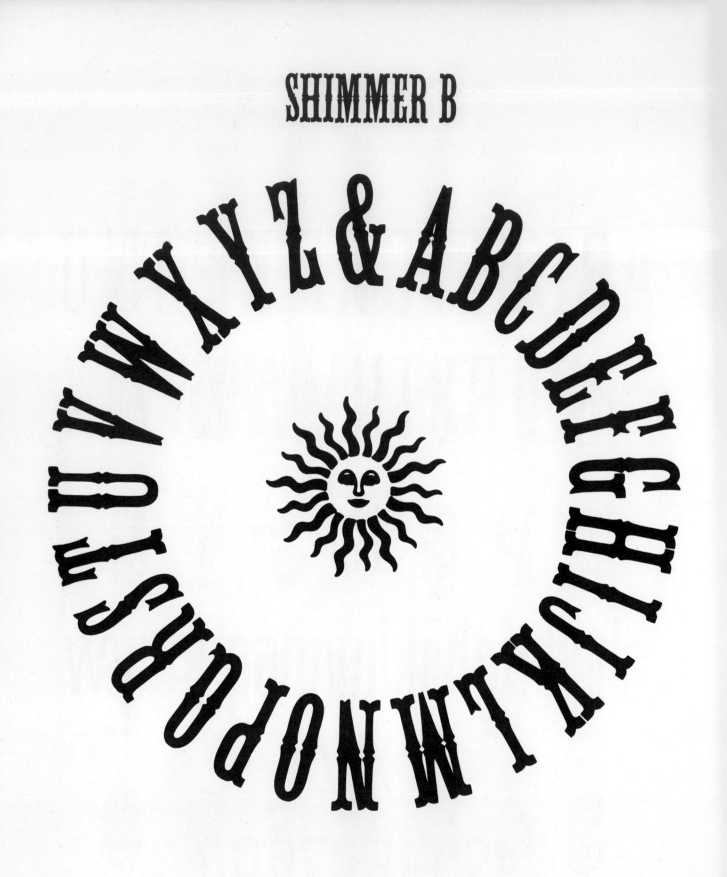

Signum

ABCDEFGHIJKLMNO
PQRSTUVWXYZ

abcdefghijklmnopqrstuvw
xyz
1234567890

Squeeze Play

ABCDEFGHJKL
MNOP
QRSTUVWXYZ

abcdefghij klmn
opqrstuvwxyz

Standard Condensed

ABCDEFGHIJKLM
NOPQRSTUVWXYZ
abcdefghijklmno
pqrstuvwxyz

1234567890(&;·!?$)

Standard Bold Condensed

ABCDEFGHIJKL
MNOPQ
RSTUVWXYZ
abcdefghijklmn
opqrstuvwxyz

1234567890&,-!?

Steinschrift Eng

ABCDEFGHIJK
LMNOPQRST
UVWXYZ
abcdefghijklmno
pqrstuvwxyz

1234567890

ABCDEFGHIJKLM
NOPQRSTUVWXYZ
abcdefghijklmnopt
qrsuvwxyz
1234567890&!;*$

TANGLEWOOD CONDENSED

ABCDEFGHIJ

KLMNOPQRS

TUVWXYZ&!?

1234567890

Tivoli Condensed

ABCDEFGHIJKLM

NOPQRSTUVWXYZ

abcdefghijklmn

opqrstuvwxyz

1234567890£$;-'!?

Tombola

ABCDEFGHIJKLMN
OPQRSTUVWXYZ
abcdefghijklmnopqrt
SUVWXYZ
$1234567890&!

Tower

ABCDEFGHIJ
KLMNOPQRST
UVWXYZ

abcdefghijklmn
opqrstuvwxyz

1234567890

ABCDEFGHIJ
KLMNOPQRS
TUVWXYZ$!?
1234567890

Typewriter Squeezed

ABCDEFGHIJKLM
NOPQRSTUVWXYZ

abcdefghijklmn
opqrstuvwxyz

(&;'!?£$¢)
1234567890

Univers 39

ABCDEFGHIJKLM
NOPQRSTUVWXYZ

abcdefghijklmnopqrstuvwxyz

(&,.!?$)

1234567890

Vendome Condensed

ABCDEFGHIJKLM
NOPQRSTUVWXYZ
abcdefghijklmn
opqrstuvwxyz
(&.,;"""!?$)
1234567890

Venus Extrabold Condensed

ABCDEFGHIJKLM
N
OPQRSTUVWXYZ
&
abcdefghijklmno
pqrstuvwxyz

1234567890$

VERBENA

ABCDEFGHIJ
KLMNOPQRS
TUVWXYZ&!$
1234567890

Windsor Elongated

ABCDEFGHIJKL
MNOPQRS
TUVWXYZ
abcdefghijklmnop
qrstuvwxyz

1234567890$&!?

Windsor Gothic Narrow

ABCDEFGHIJKLMN
OPQRSTUVWXYZ

abcdefghijklmnop
qrstuvwxyz

1234567890 (&;.!?$¢)

Windsor Light Extra Condensed

ABCDEFGHIJKLM
NOPQRSTUVWXYZ

abcdefghijklmn
opqrstuvwxyz

1234567890&;-'!?$

Wonderland

ABCDEFGHI
JKLMNOPQR
STUVWXYZ

abcdefghijklmn
opqrstuvwxyz